paperblanks®
LANG'S FAIRY
BOOKS

Cette image captivante provient d'une collection de douze livres, plus connus sous le nom de *Lang's Fairy Books* (ou *Andrew Lang's Fairy Books of Many Colours*). Compilés par Andrew Lang, illustrés par Henry Justice Ford et publiés sous la direction éditoriale de l'épouse de M. Lang, Leonora Alleyne, les livres ont fait sensation auprès des élèves britanniques et ont été vendus dans le monde entier. Chaque livre de la série est nommé d'après la couleur de sa fée sur la couverture, et ce carnet Fée Verte reproduit la page de couverture de la première édition du livre.
Lang était un poète, romancier et anthropologue écossais spécialisé dans la collecte de contes de fées du monde entier. Publié en 1907, son livre *Olive Fairy Book* contient des récits tels que « The Golden-Headed Fish » et « The Prince and the Princess in the Forest », rassemblés dans des endroits comme la Turquie, l'Inde, le Danemark, l'Arménie et le Soudan. L'illustration Fée Verte de H.J. Ford offre une qualité botanique donnant un sens de réalisme scientifique.
Que la fée verte apporte une touche de fantaisie vintage à vos écrits.

Dieses bezaubernde Bild stammt aus einer Kollektion von zwölf Büchern, die als *Lang's Fairy Books* (oder *Andrew Lang's Fairy Books of Many Colours*) bekannt ist. Zusammengestellt von Andrew Lang, illustriert von Henry Justice Ford und herausgegeben unter der redaktionellen Leitung von Langs Frau, Leonora Alleyne, waren die Bücher eine Sensation unter britischen Schulkindern und verkauften sich weltweit. Jedes Buch wurde nach der Farbe der Fee auf dem Einband benannt und auf diesem Notizbuch Olive Fairy ist der Vordereinband jener Erstausgabe abgebildet.
Lang war ein schottischer Dichter, Autor und Anthropologe, der sich darauf spezialisierte, Folklore und Märchen aus aller Welt zu sammeln. Das 1907 erschienene *Olive Fairy Book* enthält Märchen wie „Der Fisch mit dem goldenen Kopf" und „Prinz und Prinzessin im Wald", die Lang u. A. in der Türkei, Indien, Dänemark, Armenien und dem Sudan fand. Fords Zeichnung der Fee in Olive verleiht ihr durch botanische, fast insektenhafte Züge einen wissenschaftlichen Realismus, aber auch mögliche hellseherische Kräfte.
Möge die Fee in Olive Ihre Texte mit einer Prise Fantasie aus Kindertagen bestäuben.

Questa accattivante immagine proviene da una collana di dodici libri nota come *Lang's Fairy Books*, i libri colorati delle fate di Andrew Lang. Questi libri, redatti da Lang, illustrati da Henry Justice Ford e pubblicati sotto la direzione editorial della moglie di Lang, Leonora Alleyne, ebbero un grande successo tra gli studenti britannici e furono venduti in tutto il mondo. I titoli s'ispiravano ai colori delle fate protagoniste, e il nostro diario La Fata Oliva riproduce la copertina della prima edizione del volume che narra la storia di questa fata.
Poeta, romanziere e antropologo scozzese, Lang si specializzò nella narrativa popolare e nelle storie di fate. *The Olive Fairy Book*, pubblicato nel 1907, racchiude storie come "The Golden-Headed Fish", "The Prince and the Princess in the Forest" e racconti ritrovati in paesi come Turchia, India, Danimarca, Armenia e Sudan. L'illustrazione realizzata da H.J. Ford per questo libro racchiude fantastiche possibilità e possiede qualità botaniche ed entomologiche uniche, che conferiscono al disegno un realismo quasi scientifico.
Lasciatevi ispirare dalla stravaganza vintage di La Fata Oliva.

Esta delicada imagen aparece en uno de los doce libros de cuentos de la colección *Lang's Fairy Books* (o *Andrew Lang's Fairy Books of Many Colours*). Estas historias, recopiladas por Andrew Lang, ilustradas por Henry Justice Ford y publicadas bajo la dirección editorial de Leonora Alleyne, la mujer de Lang, tuvieron un gran éxito entre los escolares británicos y se vendieron en todo el mundo. Cada uno de los libros de la serie debe su título al color del hada protagonista, y en nuestro diario recreamos la cubierta de la primera edición del libro del Hada Oliva.
Lang fue un poeta, novelista y antropólogo escocés dedicado a la recopilación de cuentos de hadas y del folclore tradicional de todo el mundo. Su *Olive Fairy Book*, publicado en 1907, incluye historias de Turquía, India, Dinamarca, Armenia y Sudán, como «El pez de la cabeza dorada» y «El príncipe y la princesa en el bosque». La ilustración de H.J. Ford que decora nuestra cubierta tiene una estética vegetal y casi insectil que le da un toque de realismo científico y misticismo.
Esperamos que el mundo de fantasía del Hada Oliva le inspire en todo lo que escriba.

この幻想的なデザインは、12冊の双書からなる『ラング世界童話集』(または『アンドルー・ラング世界童話集』)がモチーフ。アンドルー・ラングが編纂し、ヘンリー・ジャスティス・フォードが挿絵を入れ、ラングの妻のレオノーラ・アレンの編集・監督の下で制作されたこの童話集は、イギリスの子どもたちに愛され、のちに世界中で刊行されました。妖精の色にちなんだ題名がそれぞれの本に付けられており、本装丁『くさいろの童話集』初版の表紙を再現しています。
ラングはスコットランド生まれの詩人/小説家/人類学者で、世界各国の民話やおとぎ話の収集家としても知られています。1907年に出版された『くさいろの童話集』は、トルコやインド、デンマーク、アルメニア、スーダンなどから「金色の頭の魚」「森のなかの王子と王女」といった物語を集めた一冊。H・J・フォードの絵に描かれる妖精は、植物にも昆虫にも見える容姿を持ち、その存在を科学的に証明できるような感覚と超現実的なテイストを併せ持っています。
この「くさいろの妖精」が、ビンテージのように味わい深い文章を書く手助けになることを願ってやみません。

paperblanks®
LANG'S FAIRY
BOOKS

Olive Fairy

This captivating image comes from a collection of 12 books, known as *Lang's Fairy Books* (or *Andrew Lang's Fairy Books of Many Colours*). Compiled by Andrew Lang, illustrated by Henry Justice Ford and published under the editorial direction of Lang's wife, Leonora Alleyne, the books were a sensation among British schoolchildren and were sold all around the world. Each book in the series was named for the colour of its featured fairy, and this Olive Fairy journal reproduces the front cover of that book's first edition.

Lang was a Scottish poet, novelist and anthropologist who specialized in collecting folk and fairy tales from around the globe. Published in 1907, his *Olive Fairy Book* includes stories such as "The Golden-Headed Fish" and "The Prince and the Princess in the Forest" gathered from places like Turkey, India, Denmark, Armenia and the Sudan. H.J Ford's Olive Fairy illustration offers a botanical and almost insectile quality that gives her a sense of scientific realism as well as fey possibility.

May the Olive Fairy bring a hint of vintage whimsy to your writings.

ISBN: 978-1-4397-6503-6
ULTRA FORMAT 144 PAGES LINED
DESIGNED IN CANADA